Lisa
whatever
goddess you
choose to
be !
lots of love
Lara

DOMESTIC GODDESSES

EDITH VONNEGUT

Pomegranate

SAN FRANCISCO

Dedicated to all women who get their hands dirty,
and specifically to my mother, Jane Marie Cox Vonnegut

Published by Pomegranate Communications, Inc.
Box 6099, Rohnert Park, CA 94927

Pomegranate Europe Ltd.
Fullbridge House, Fullbridge
Maldon, Essex CM9 4LE, England

Photographs of the following images courtesy of The Bridgeman Art Library International Ltd. London/ New York: *The Alba Madonna* (c. 1510) by Raphael Sanzio of Urbino (1483–1520), National Gallery of Art, Washington D.C.; *Napoleon Crossing the Alps* (c. 1800) by Jacques-Louis David (1748–1825), Schloss Charlottenburg, Berlin; *Danae* (1546–1553) by Titian (Tiziano Vecelli) (c. 1488–1576), The Hermitage, St. Petersburg; *The Descent from the Cross* (1704-1710) by Jean-Baptiste Jouvenet (1644–1717) The Hermitage, St. Petersburg; *Rape of the Daughters of Leucippus* (c. 1618) by Peter Paul Rubens (1577–1640), Alte Pinakothek, Munich; *Primavera*, detail of *The Three Graces* (1477–1478) by Sandro Botticelli (1445–1510), Galleria degli Uffizi, Florence; *Ruggiero Rescuing Angelica* (1819) by Jean-Auguste-Dominique Ingres (1780–1867), The Louvre, Paris, Photograph by Peter Willi.

Pomegranate Catalog No. A502
ISBN 0-7649-0687-9

Library of Congress Cataloging-in-Publication Data

Vonnegut, Edith
 Domestic goddesses / Edith Vonnegut.
 p. cm.
 ISBN 0–7649–0687–9 (hardcover ; alk. paper)
 1. Vonnegut, Edith—Themes, motives. 2. Women in art. I. Title.
 ND237.V696A4 1998
 759. 13—dc21 98–18217
 CIP

Cover and interior design by Poulson/Gluck Design

Printed in China
07 06 05 04 03 02 01 00 99 98 10 9 8 7 6 5 4 3 2 1

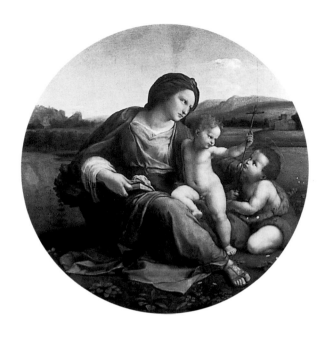

SINCE THE BEGINNING OF RECORDED PAINTED HISTORY,

MEN HAVE HAD THEIR WAY WITH THE IMAGES OF WOMEN.

THEY ARE EXTRAORDINARILY LOVELY, BUT THEY ARE MEN'S

IMAGES. THE MOTHER MADONNAS ARE STILL AND SERENE,

USUALLY PICTURED IN A SHELTERED SETTING, UNFETTERED

BY WORRIES. THEIR CHILDREN ARE WELL BEHAVED,

CLEAN, AND OFTEN SLEEPING IN THEIR LAPS.

ALL IS PEACEFUL . . .

"THE ALBA MADONNA" BY RAPHAEL

A WOMAN'S WORLD IS NOT A DREAMY,

ENCHANTED IDYLL.

IT'S MORE LIKE THE MARINES.

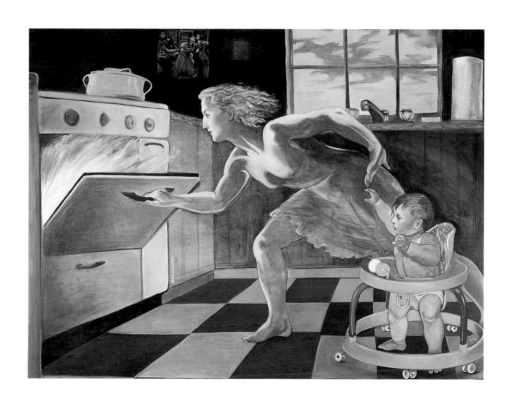

HOT!!

THE IMAGES OF WOMEN SHOULD BE INFUSED

WITH VIGOR, STRENGTH, AND PARTICIPATION.

WE NEED POWERFUL ALLEGORIES.

WE NEVER JUST SAT AROUND.

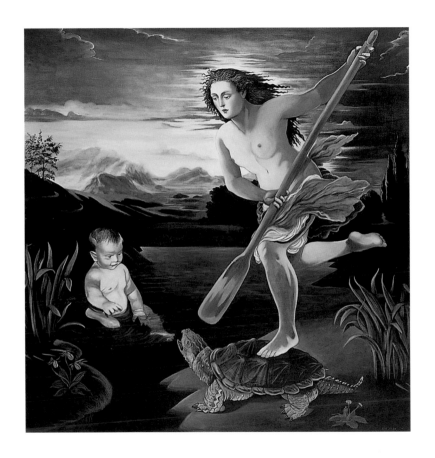

MOTHERHOOD

WE ARE BUSY DOING THE DISHES . . .

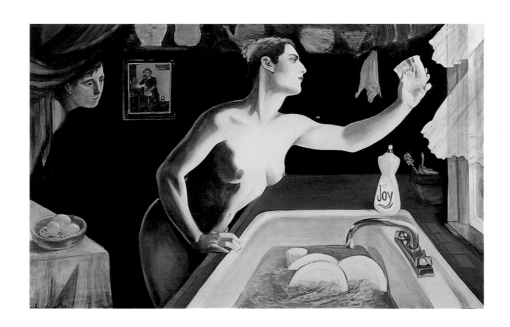

JOY

SCRUBBING THE FLOORS . . .

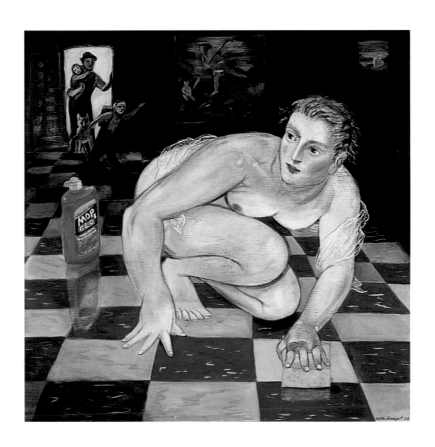

MOP 'N' GLOW

AND PUTTING OUT THE WASH.

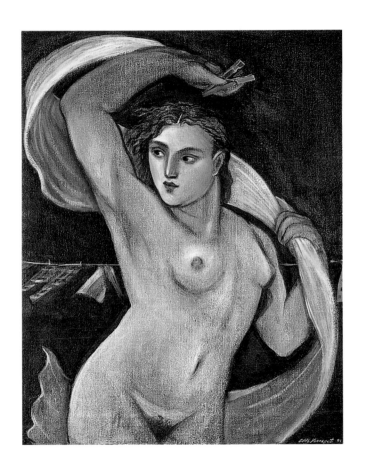

HANGING THE LAUNDRY

We protect our children from harm . . .

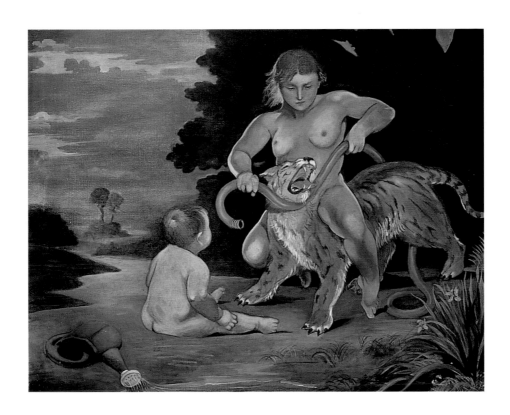

GARDEN HOSE

AND WE'RE THERE WHEN THEY NEED US.

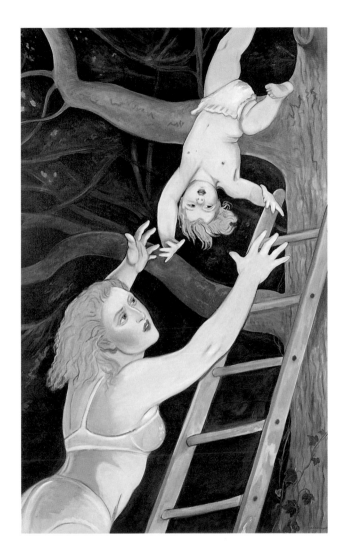

FALLING

WE KEEP THEM FROM UNWISE CHOICES.

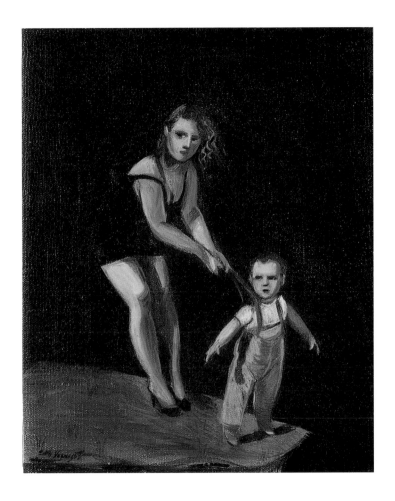

OVER THE CLIFF

We have super-human strength when it's called for, and we deserve to be depicted in heroic proportions . . .

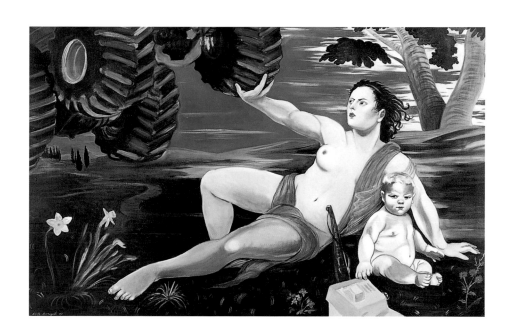

4 WHEEL DRIVE

EVEN IF WE'RE JUST VACUUMING . . .

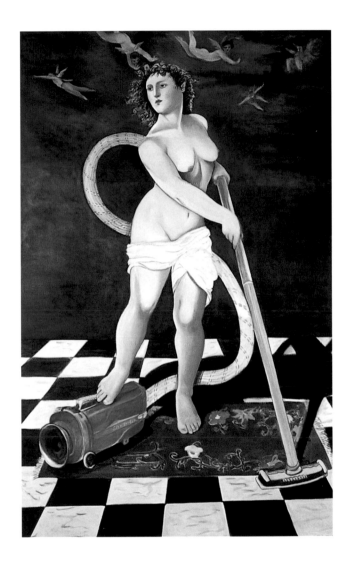

ELECTROLUX

OR GETTING THE DUST BALLS FROM UNDER THE BED . . .

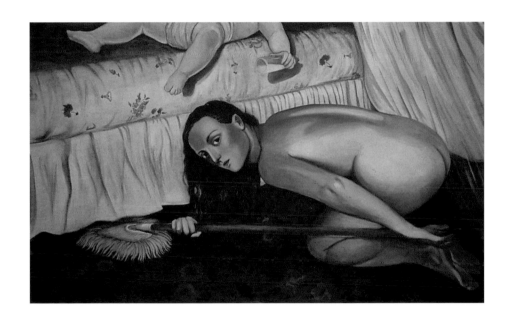

DUST BALLS

BECAUSE WE TAKE CARE OF ALL THE LITTLE THINGS

WITH GRACE AND DIGNITY.

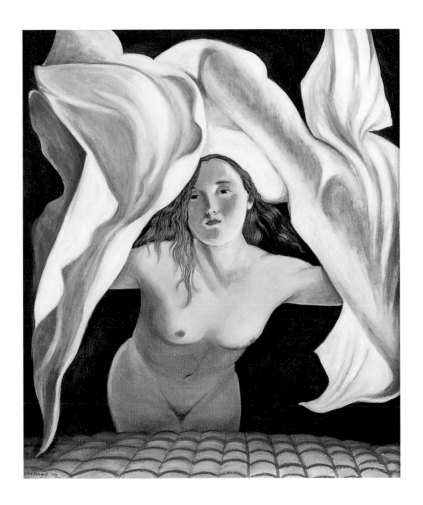

MAKING THE BED

WHY HAVEN'T WE BEEN PORTRAYED WITH

MORE VITALITY AND GRANDEUR?

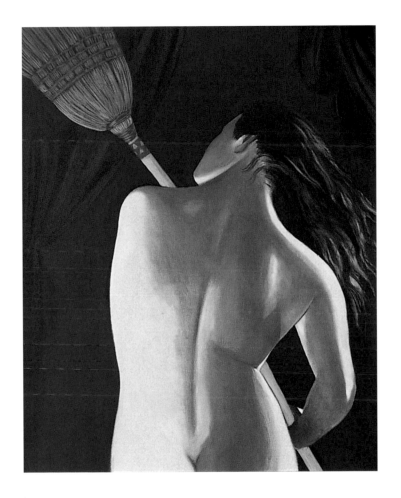

SWEEPING

NAPOLÉON WAS SHORT, NOT VERY ATTRACTIVE,

AND HAD DIFFICULTY RIDING A HORSE.

HOW COME HE GOT TO LOOK LIKE THIS?

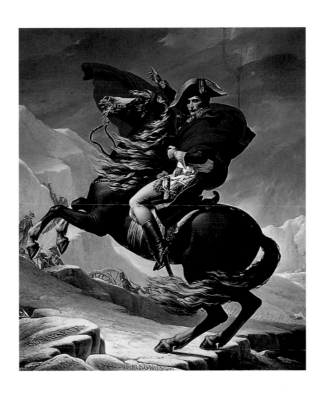

"NAPOLEON CROSSING THE ALPS" BY DAVID

THERE IS MORE HONOR IN TAKING OUT THE GARBAGE

THAN IN MAKING WAR.

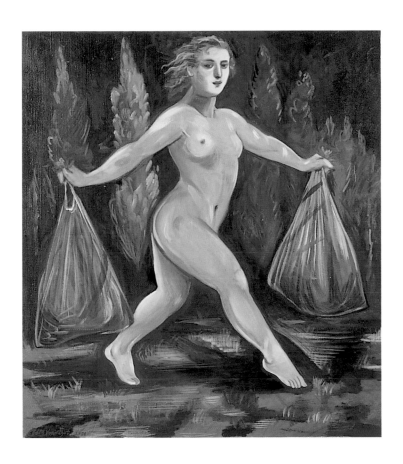

TAKING OUT THE GARBAGE

THERE IS MORE COURAGE IN CARING FOR A CHILD THAN

IN PLUNGING A SPEAR INTO SOMEONE'S CHEST.

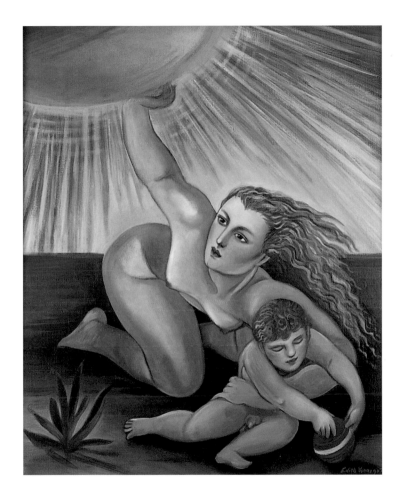

SUN BLOCK

OUR BATTLES ARE FOUGHT IN THE SUPERMARKET AISLES

OVER GOOD NUTRITION . . .

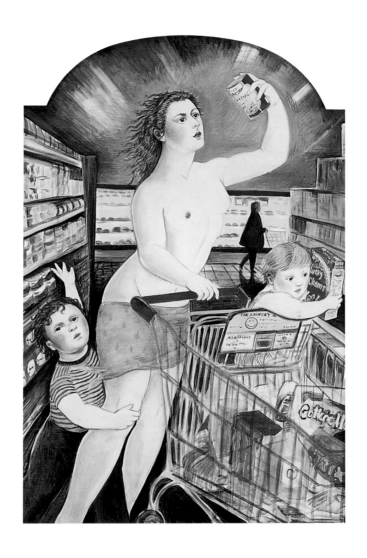

BEEFARONI OR BATTLE IN THE AISLES

AND IN THE SPLASH POOLS . . .

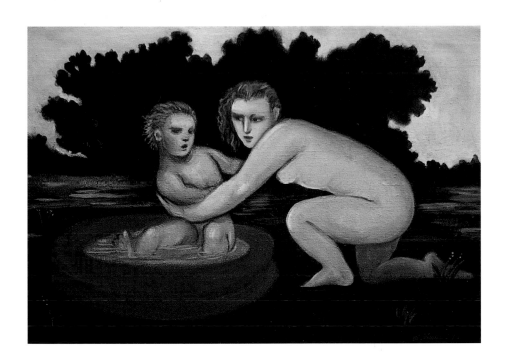

TIME TO COME OUT

AND IN THE WATER WHEN THE TIDE COMES IN.

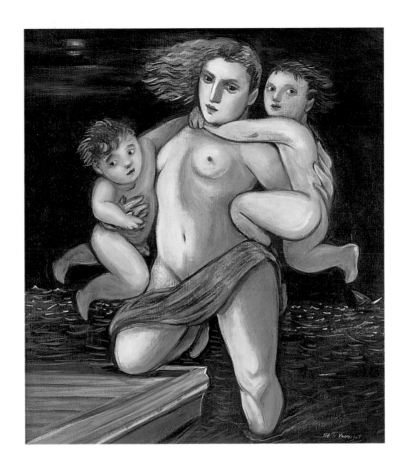

RIP-TIDE

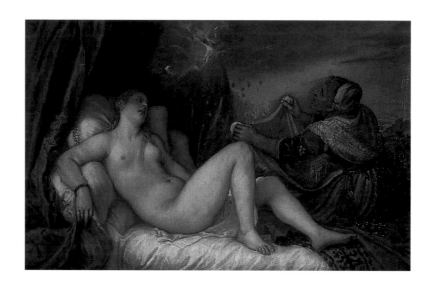

THERE ARE THOUSANDS OF PAINTINGS OF WOMEN LYING

AROUND NAKED DOING ABSOLUTELY NOTHING.

"DANAE" BY TITIAN

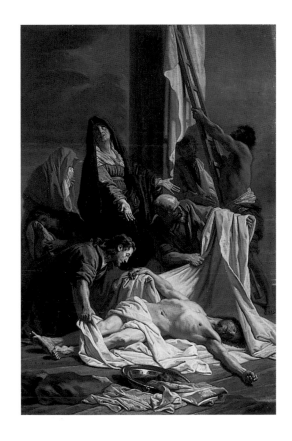

THE ONLY TIME YOU SEE A MAN LYING AROUND NAKED DOING

NOTHING IS IF HE'S DEAD, JESUS CHRIST, OR BOTH.

"THE DESCENT FROM THE CROSS" BY JEAN-BAPTISTE JOUVENET

WE DON'T HAVE TIME FOR NAPS.

THERE ARE CHILDREN TO FEED . . .

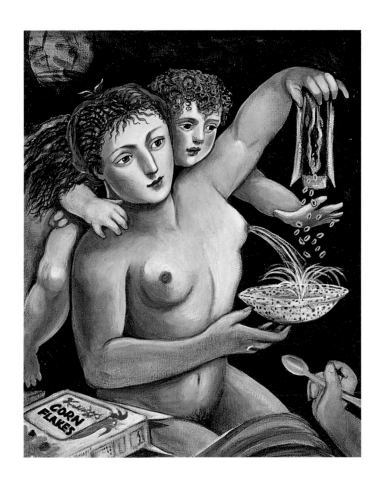

BREAKFAST TIME

CLOTHES TO PRESS . . .

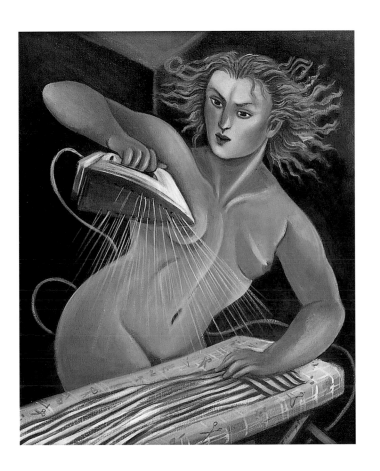

IRONING

AND REFRIGERATORS TO STOCK.

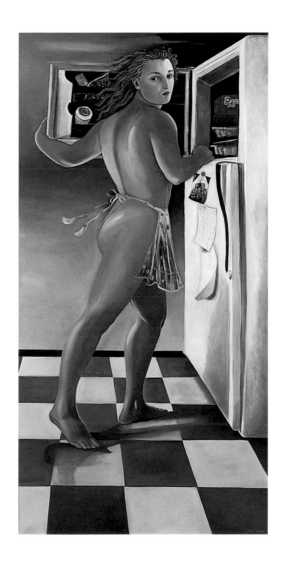

GODDESS IN THE FREEZER

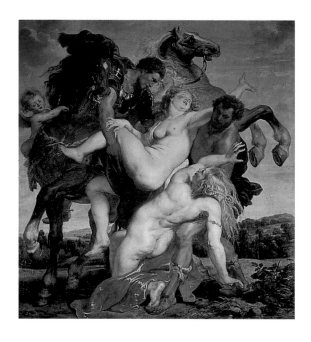

OFTEN IN THE PAST WHEN A WOMAN WAS

PORTRAYED WITH ANY ENERGY, SHE WAS SHOWN

TRYING TO AVOID GETTING RAPED OR KILLED,

USUALLY IN VAIN . . .

"RAPE OF THE DAUGHTERS OF LEUCIPPUS" BY RUBENS

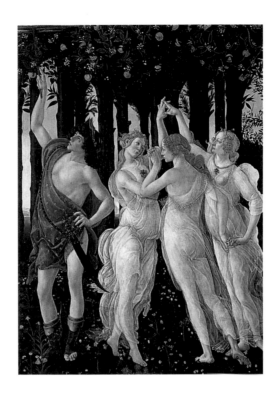

OR PRANCING IN SOME FRUITY DANCE SEQUENCE.

"PRIMAVERA" (DETAIL OF "THE THREE GRACES") BY BOTTICELLI

WE ARE NOT SLUMPED IN A USELESS SWOON.

WE ARE NOT LIVING IN A STATE OF PANIC.

WE ARE NOT WHIRLING WITHOUT PURPOSE.

WE HAVE CHORES TO DO . . .

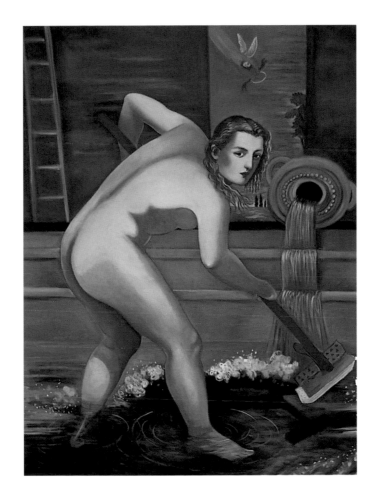

ETERNAL MOPPING

BUSES TO CATCH . . .

54

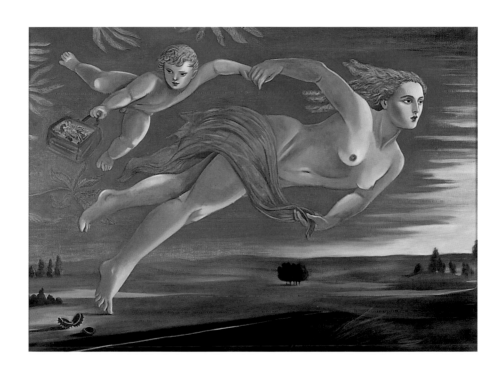

CATCHING THE BUS

STAIRS TO CLEAN . . .

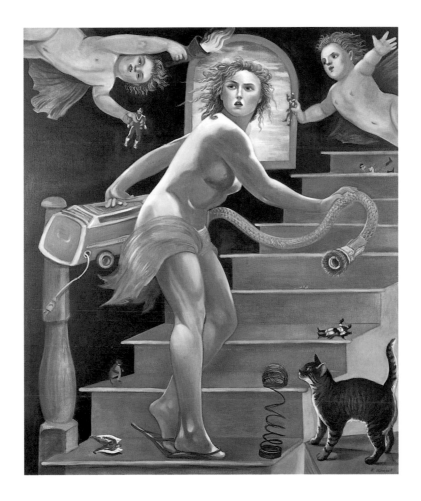

ACTION FIGURES

AND CHILDREN TO RAISE.

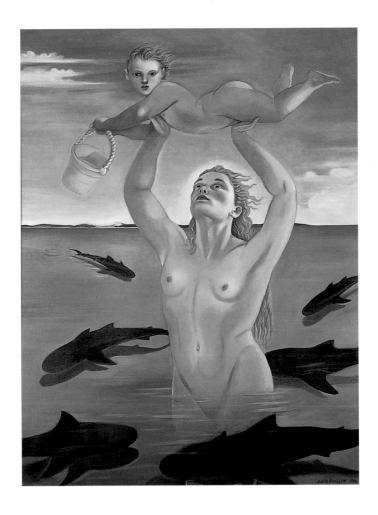

SHARK ATTACK

So why are the women in paintings so often relegated to the background, helplessly waiting while someone else slays the dragon?

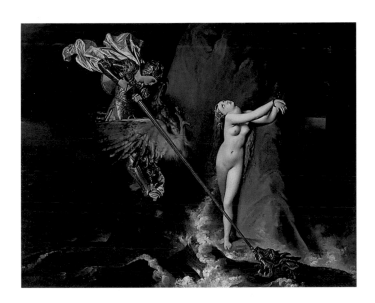

"RUGGIERO RESCUING ANGELICA" BY JEAN-AUGUSTE-DOMINIQUE INGRES

WE SLAY DRAGONS ALL THE TIME.

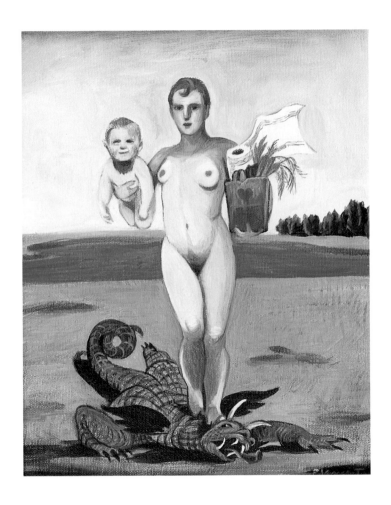

SLAYING THE DRAGON AND DOING THE SHOPPING

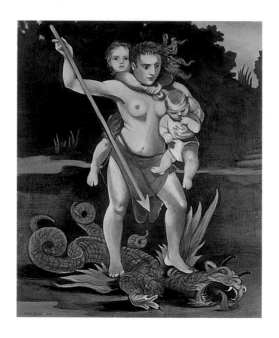

WOMEN ARE THE PROTECTORS OF ALL MEN AND WOMEN FOR THE FIRST,

MOST VULNERABLE PART OF THEIR LIVES. TO PORTRAY US AS PASSIVE,

WEAK, AND HELPLESS IS A LIE AND A WASTE OF ENERGY.

WE HAVE A VITAL HAND IN THE FORMING, PRESERVING,

AND DEFENDING OF LIFE, DESERVING OF MAJESTIC

REPRESENTATION BEFITTING PEOPLE OF VALOR.

DRAGON SLAYER WITH TWO SONS